At the J. Paul Getty Museum

Christopher Hudson, Publisher
Mark Greenberg, Managing Editor
Shelly Kale, Editor
Markus Brilling, cover design

First published in the United States in 1999 by
The J. Paul Getty Museum
1200 Getty Center Drive
Suite 1000
Los Angeles, California 90049-1687
www.getty.edu/publications

*Alpha and Omega: Visions of the Millennium* © Frances Lincoln Limited 1999

First published in Great Britain in 1999 by
Frances Lincoln Limited, 4 Torriano Mews,
Torriano Avenue, London NW5 2RZ

Extracts from the Authorized Version of the Bible (The King James Bible), the
rights in which are vested in the Crown, are reproduced by permission of the
Crown's Patentee, Cambridge University Press.

Excerpts from *Les visions du chevalier Tondal* (J. Paul Getty Museum, MS. 30), on
pages 30 and 52, were first published in *The Visions of Tondal: From the Library of
Margaret of York* by Thomas Kren and Roger S. Wieck (Malibu: California: The
J. Paul Getty Museum, 1990), pp. 44, 50; translated by Madeleine McDermott and
Roger S. Wieck.

For photographic acknowledgments and copyright details, see pages 72-77.

Library of Congress Cataloging-in-Publication Data
Alpha and omega: visions of the millennium: words from the Revelation of St. John
the Divine: prophetic paintings from the world's great art museums.
p.   cm.
ISBN  0-89236-576-5
I. Bible. N.T. Revelation Quotations. I. J. Paul Getty Museum.
II. Bible. N.T. Revelation. English. 1999.

BS2825.5.A56  1999

99-26505
CIP

Set in Baker Signet
Printed in Hong Kong
1 3 5 7 9 8 6 4 2

# Alpha and Omega

## Visions of the Millennium

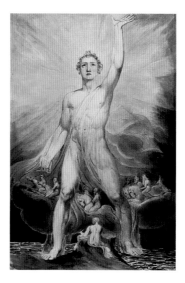

THE J. PAUL GETTY MUSEUM
LOS ANGELES

# T

HIS BOOK TAKES THE READER on a unique journey through visionary art of the Middle Ages, the Renaissance, and the nineteenth century. The illustrations are accompanied by selections from the apocalyptic *Revelation of St. John the Divine* as well as from *Les Visions du chevalier Tondal (The Visions of Tondal)*, a Burgundian illuminated manuscript in the collection of the J. Paul Getty Museum.

St. John's biblical text has inspired artists for the last two thousand years; it continues to fascinate the imaginations of contemporary men and women who are drawn to its visionary power. *The Visions of Tondal* was one of the most widely read of all the medieval tales describing journeys to the hereafter. A reflection of man's attempt to cope with the unknown, it was translated into all the major, and many minor, European languages after its creation in the twelfth century.

Extracts of texts from the *Revelation* are referenced by chapter and verse. Illustrating the texts written by the creator of *The Visions of Tondal* are the actual images from this influential chronicle of a visit to the next world. These dramatic texts are illuminated by some of the world's most compelling apocalyptic imagery, from the extraordinary creatures depicted by Hieronymus Bosch to Michelangelo's powerful *Last Judgment* to William Blake's mystical prophetic paintings.

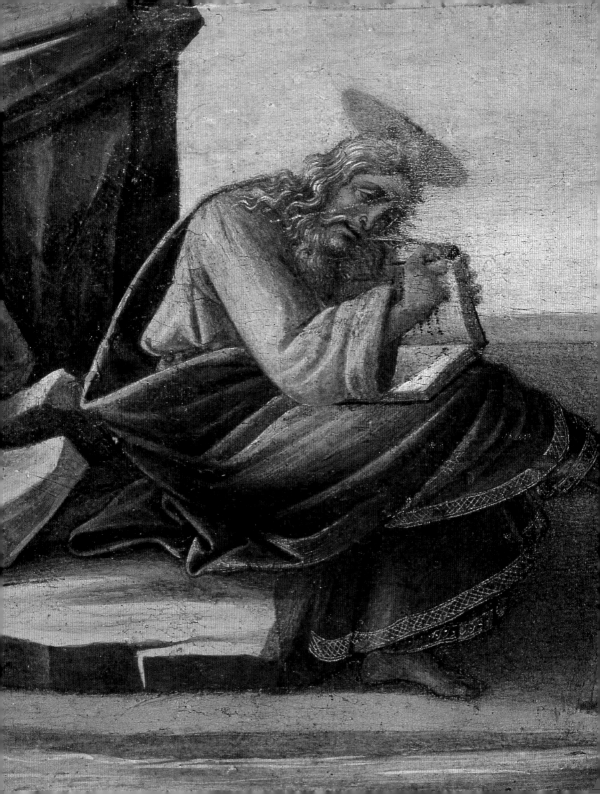

**I** JOHN, who also am your brother, and companion in tribulation, and in the kingdom and patience of Jesus Christ, was in the isle that is called Patmos, for the word of God, and for the testimony of Jesus Christ.

CHAPTER 1:9

 **WAS IN THE SPIRIT** on the Lord's day, and heard behind me a great voice, as of a trumpet,

Saying, I am Alpha and Omega, the first and the last: and, What thou seest, write in a book, and send it unto the seven churches which are in Asia.

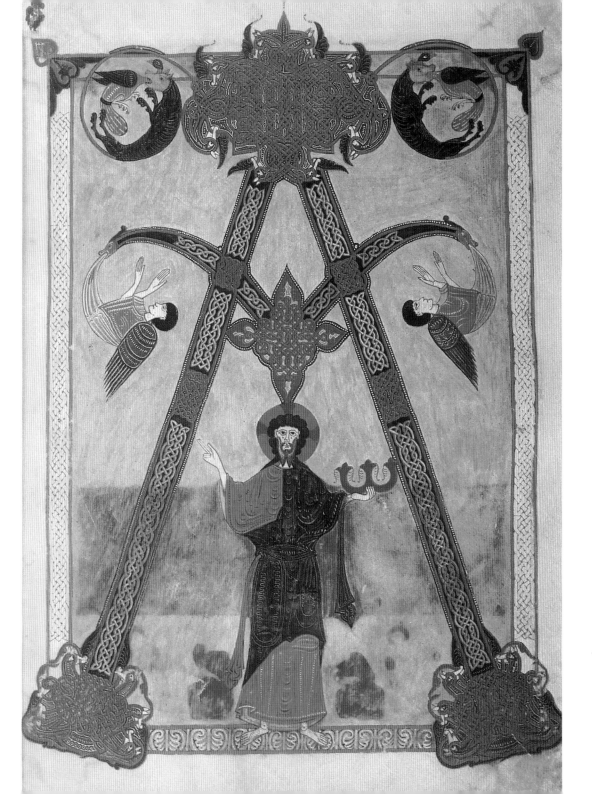

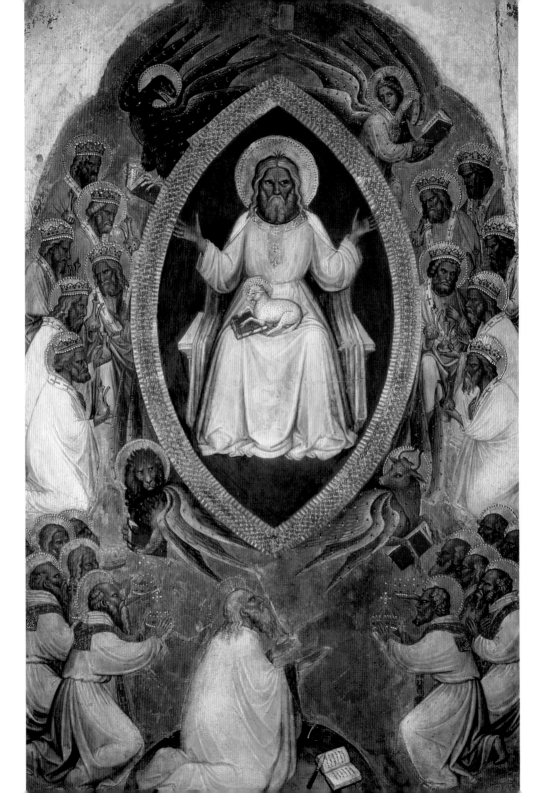

AND IMMEDIATELY I was in the spirit: and, behold, a throne was set in heaven, and one sat on the throne.

And round about the throne were four and twenty seats: and upon the seats I saw four and twenty elders sitting, clothed in white raiment; and they had on their heads crowns of gold.

CHAPTER 4: 2, 4

**ND BEFORE** the throne there was a sea of glass like unto crystal: and in the midst of the throne, and round about the throne, were four beasts full of eyes before and behind.

And the first beast was like a lion, and the second beast like a calf, and the third beast had a face as a man, and the fourth beast was like a flying eagle.

CHAPTER 4: 6-7

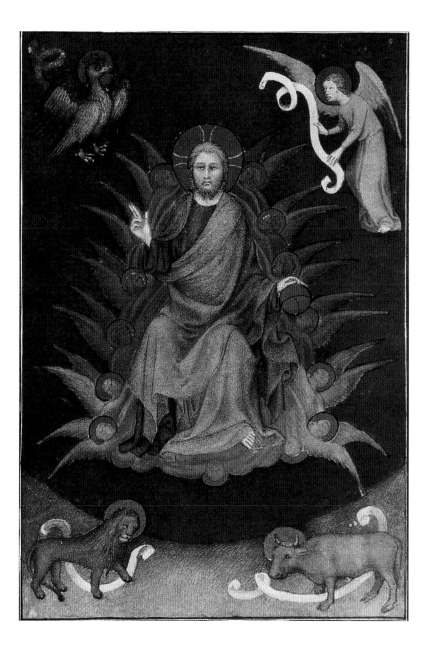

**ND I SAW** a strong angel proclaiming with a loud voice, Who is worthy to open the book, and to loose the seals thereof?

And no man in heaven, nor in earth, neither under the earth, was able to open the book, neither to look thereon.

CHAPTER 5: 2-3

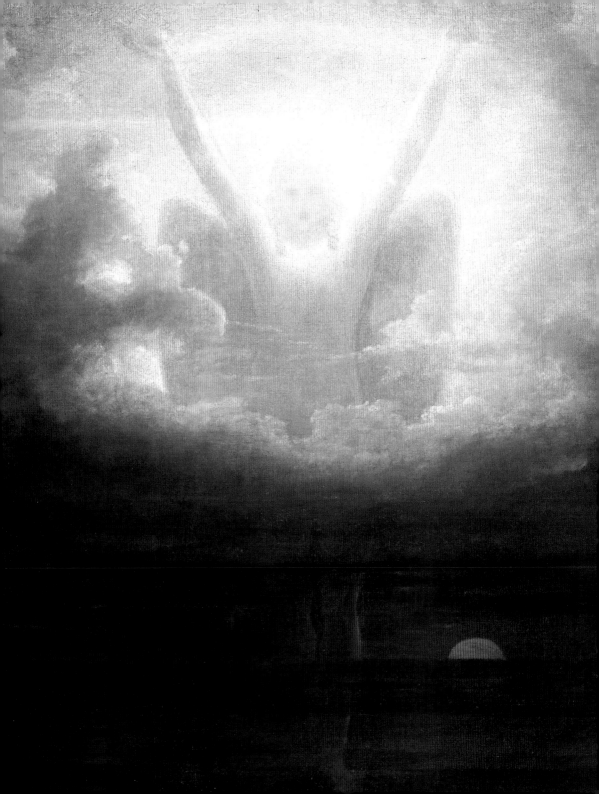

**ND I SAW** when the lamb opened one of the seals, and I heard, as it were the noise of thunder, one of the four beasts saying, Come and see.

And I saw, and behold a white horse: and he that sat on him had a bow; and a crown was given unto him ...

And when he had opened the second seal, I heard the second beast say, Come and see.

And there went out another horse that was red: and power was given unto him that sat thereon to take peace from the earth ...

And when he had opened the third seal, I heard the third beast say, Come and see. And I beheld, and lo a black horse; and he that sat on him had a pair of balances in his hand.

CHAPTER 6: 1-5

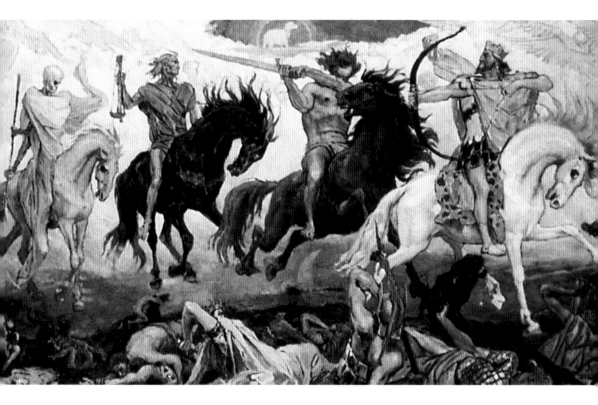

A ND I LOOKED, and behold a pale horse: and his name that sat on him was Death.

CHAPTER 6:8

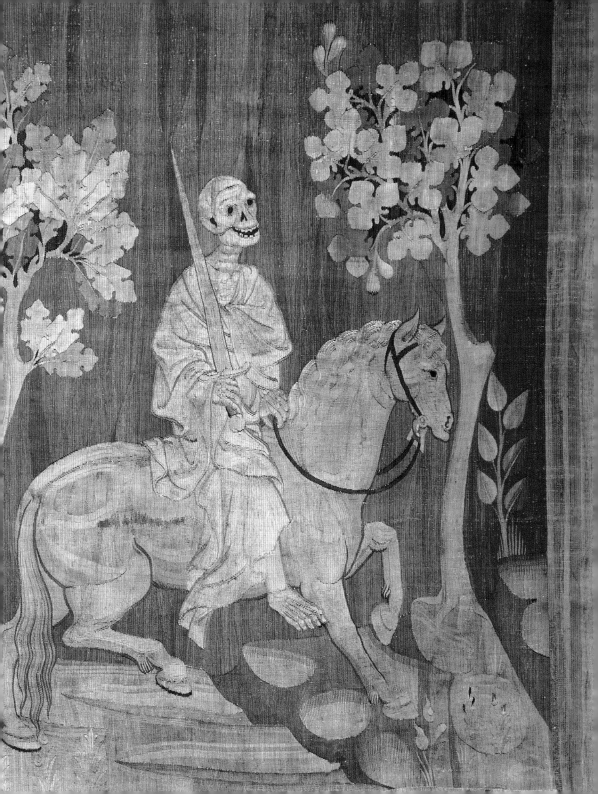

**A**ND I BEHELD when he had opened the sixth seal, and, lo, there was a great earthquake; and the sun became black as sackcloth of hair, and the moon became as blood;

And the stars of heaven fell unto the earth ...

And the kings of the earth ... and every bondman, and every free man, hid themselves in the dens and in the rocks of the mountains;

And said to the mountains and rocks, Fall on us, and hide us from the face of him that sitteth on the throne, and from the wrath of the Lamb:

For the great day of his wrath is come; and who shall be able to stand?

CHAPTER 6: 12-13, 15-17

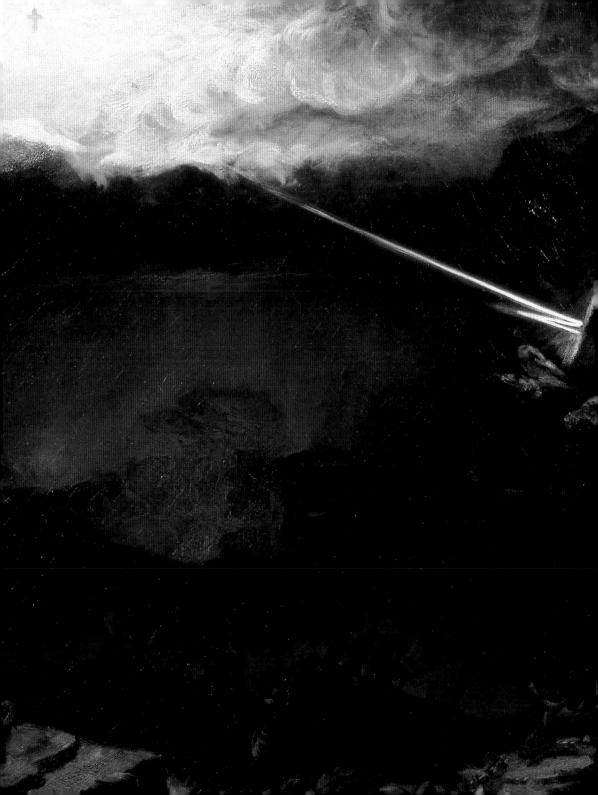

# A

ND WHEN he had opened the seventh seal, there was silence in heaven about the space of half an hour.

---

CHAPTER 8:1

**ND I SAW** the seven angels which stood before God; and to them were given seven trumpets.

The first angel sounded, and there followed hail and fire mingled with blood ...

And the second angel sounded, and as it were a great mountain burning with fire was cast into the sea: and the third part of the sea became blood.

And the third angel sounded, and there fell a great star from heaven, burning as it were a lamp, and it fell upon the third part of the rivers, and upon the fountains of waters.

CHAPTER 8: 2, 7, 8, 10

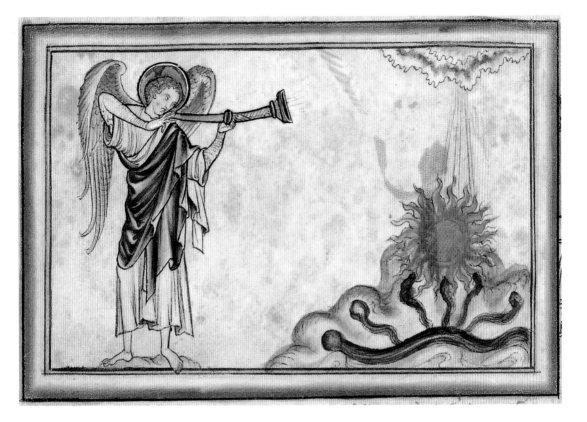

# AND THE FOURTH ANGEL

sounded, and the third part of the sun was smitten, and the third part of the moon, and the third part of the stars; so as the third part of them was darkened, and the day shone not for a third part of it, and the night likewise.

CHAPTER 8:12

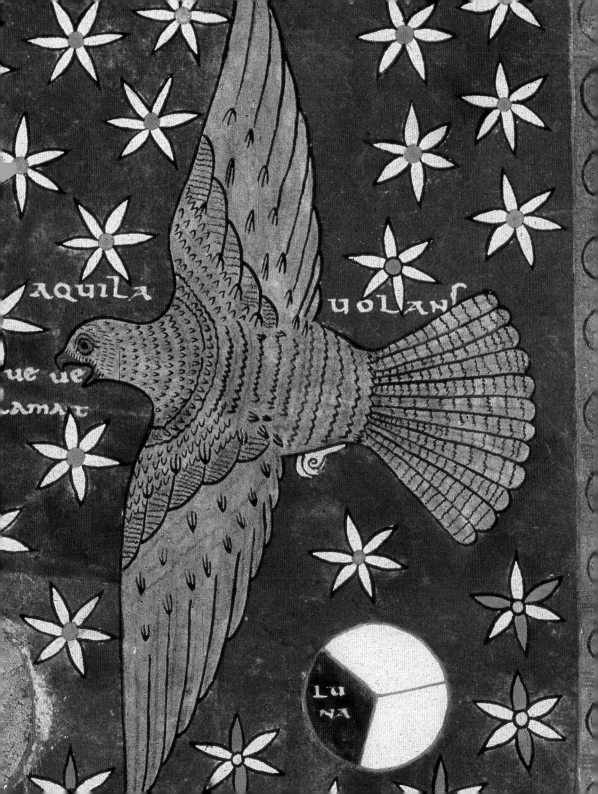

AQUILA                    UOLANS

ue ue
amt

LU
NA

HE ANGEL AND THE soul of Knight Tondal came to ... the Valley of Fires. There they found several forges and heard much lamentation. As they were approaching, the devils came to meet them, holding in their hands burning tongs of iron .... From one devil to the other, with their burning tongs they would throw and catch the souls.

THE VISIONS OF TONDAL

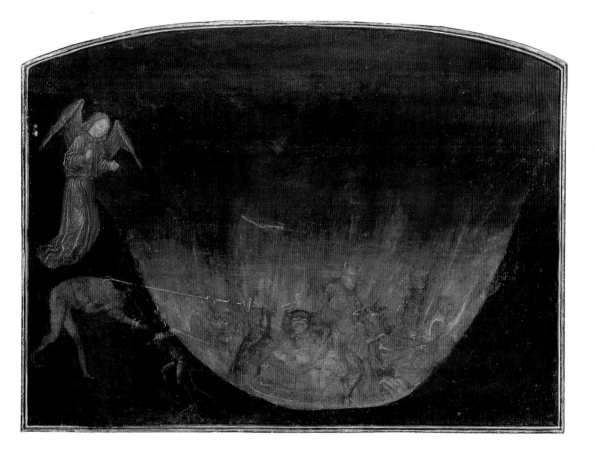

**ND THERE CAME** out of the smoke locusts upon the earth: and unto them was given power, as the scorpions of the earth have power.

And the shapes of the locusts were like unto horses prepared unto battle; and on their heads were as it were crowns like gold, and their faces were as the faces of men.

CHAPTER 9: 3, 7

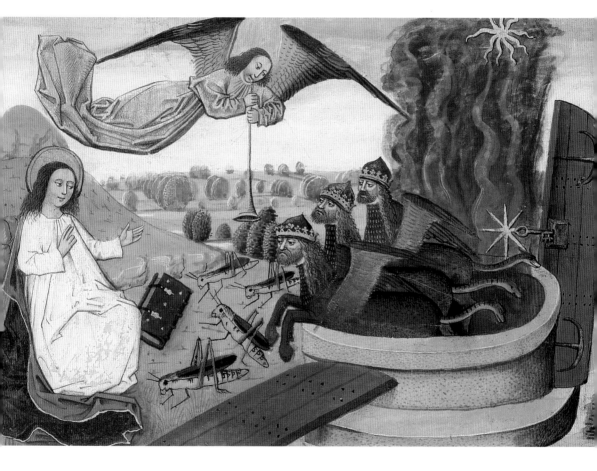

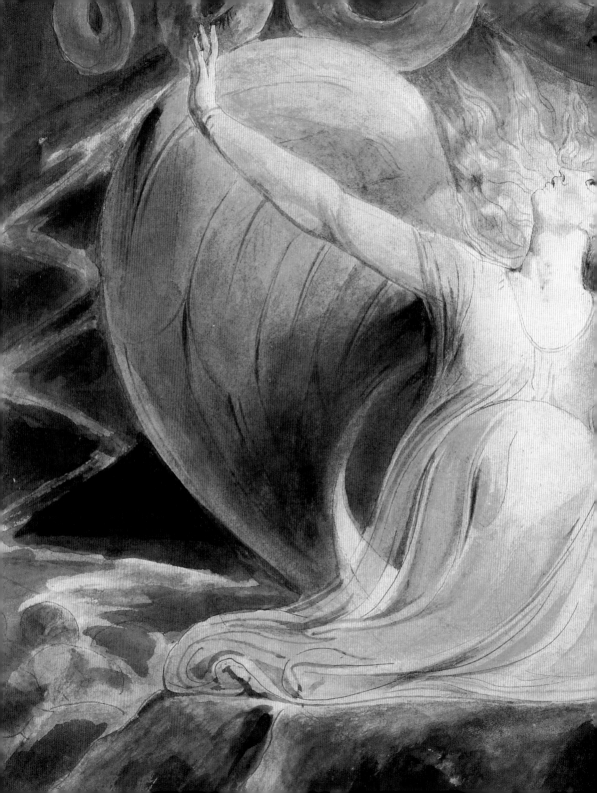

A ND THERE APPEARED a great wonder in heaven; a woman clothed with the sun, and the moon under her feet, and upon her head a crown of twelve stars:

And she being with child cried, travailing in birth, and pained to be delivered.

And there appeared another wonder in heaven; and behold a great red dragon, having seven heads and ten horns, and seven crowns upon his heads.

... And the dragon stood before the woman which was ready to be delivered, for to devour her child as soon as it was born.

CHAPTER 12: 1-4

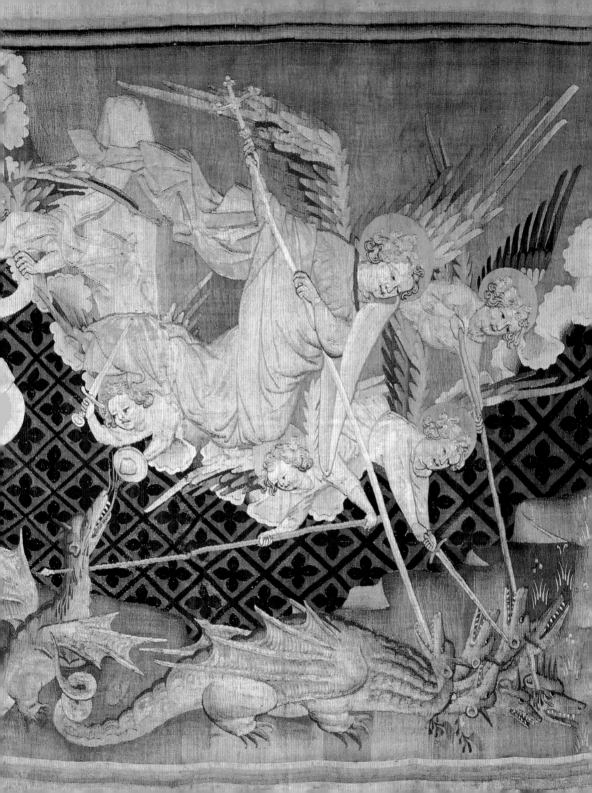

AND THERE WAS WAR in heaven: Michael and his angels fought against the dragon; and the dragon fought and his angels.

And the great dragon was cast out, that old serpent, called the Devil, and Satan, which deceiveth the whole world: he was cast out into the earth, and his angels were cast out with him.

CHAPTER 12: 7, 9

ND I STOOD upon the sand of the sea, and saw a beast rise up out of the sea, having seven heads and ten horns, and upon his horns ten crowns, and upon his heads the name of blasphemy.

And they worshipped the dragon which gave power unto the beast: and they worshipped the beast, saying, Who is like unto the beast? who is able to make war with him?

CHAPTER 13: 1, 4

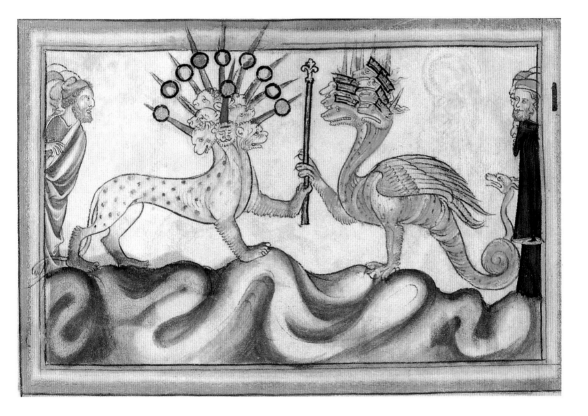

**ND I BEHELD** another beast coming up out of the earth; and he had two horns like a lamb, and he spake as a dragon.

And deceiveth them that dwell on the earth by the means of those miracles which he had power to do in the sight of the beast ...

And he causeth all, both small and great, rich and poor, free and bond, to receive a mark in their right hand, or in their foreheads:

And that no man might buy or sell, save he that had the mark, or the name of the beast, or the number of his name.

CHAPTER 13: 11, 14, 16-17

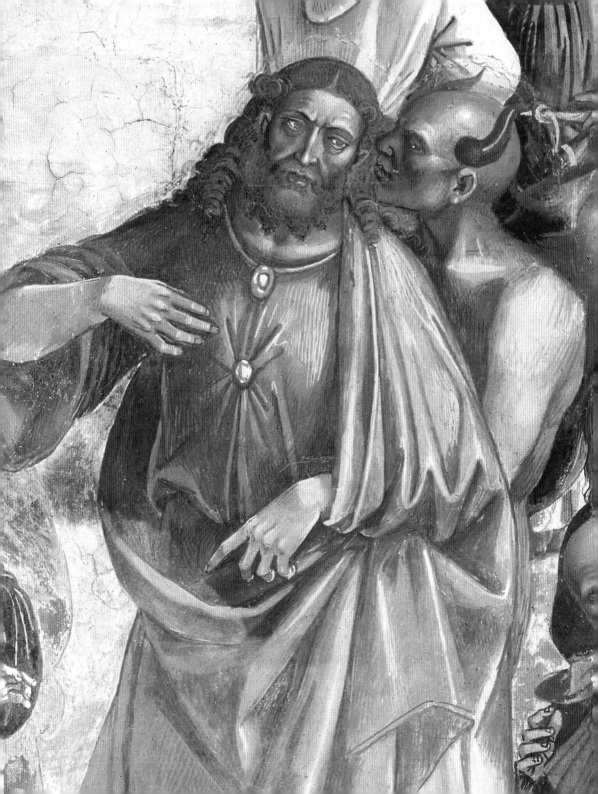

ERE IS WISDOM. Let him that hath understanding count the number of the beast: for it is the number of a man; and his number is Six hundred threescore and six.

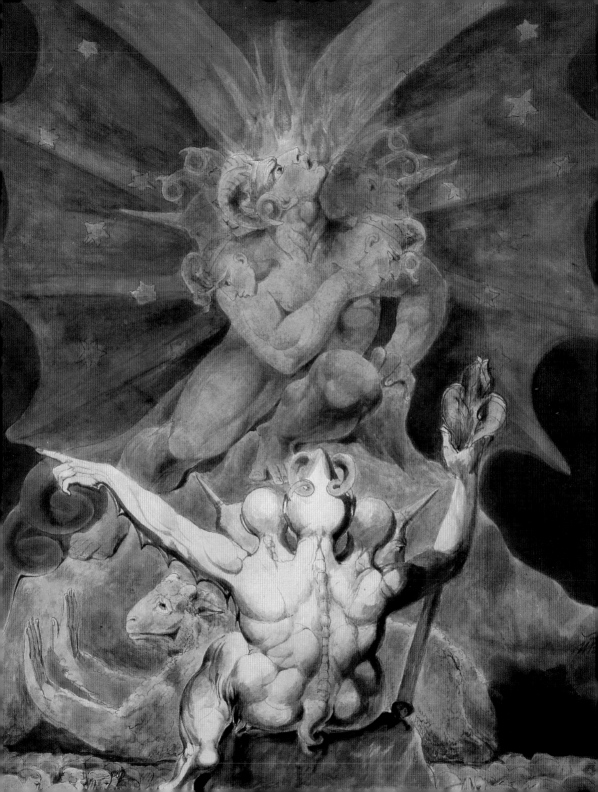

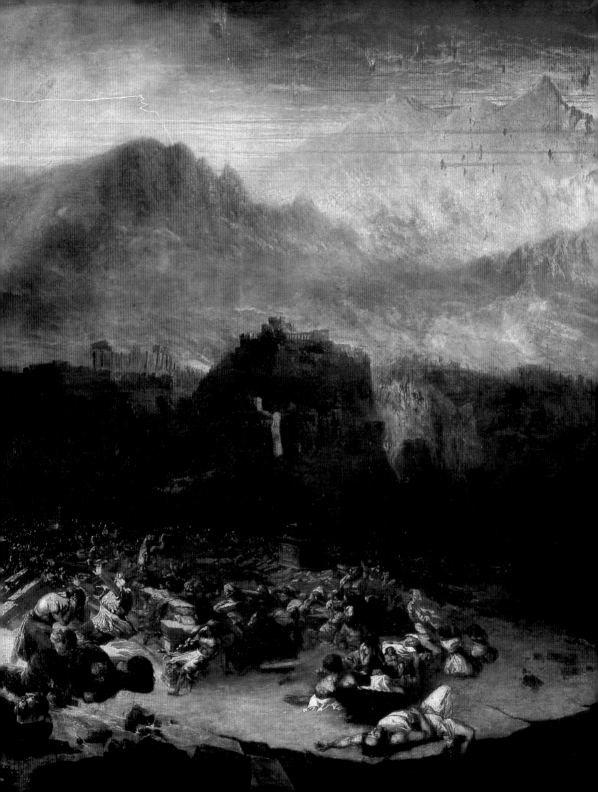

**A**ND I SAW three unclean spirits like frogs come out of the mouth of the dragon, and out of the mouth of the beast, and out of the mouth of the false prophet.

For they are the spirits of devils, working miracles, which go forth unto the kings of the earth and of the whole world, to gather them to the battle of that great day of God Almighty.

And he gathered them together into a place called in the Hebrew tongue Armageddon.

CHAPTER 16: 13-14, 16

S O HE CARRIED ME away in the spirit into the wilderness: and I saw a woman sit upon a scarlet coloured beast, full of names of blasphemy, having seven heads and ten horns.

CHAPTER 17: 3

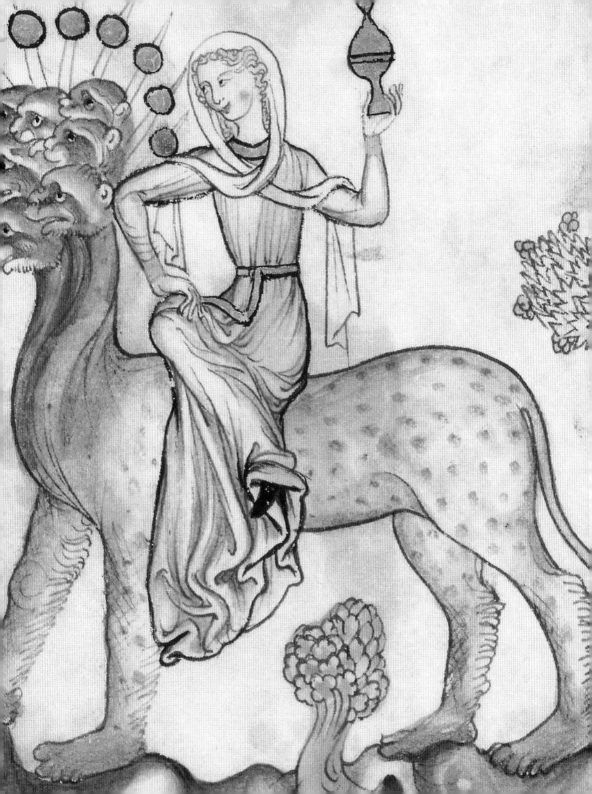

AND I SAW THE BEAST, and the kings of the earth, and their armies, gathered together to make war against him that sat on the horse, and against his army.

And the beast was taken, and with him the false prophet that wrought miracles before him, with which he deceived them that had received the mark of the beast, and them that worshipped his image. These both were cast alive into a lake of fire burning with brimstone.

CHAPTER 19: 19-20

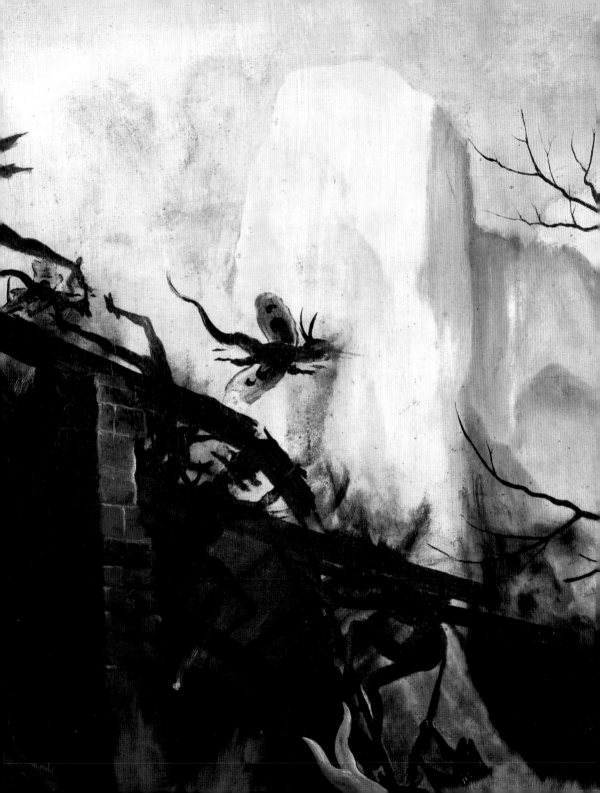

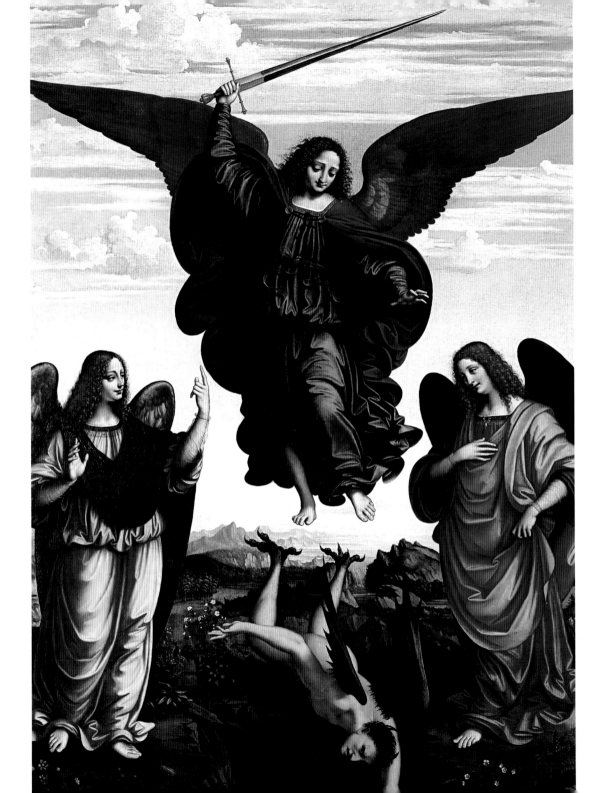

ND I SAW an angel come down from heaven, having the key of the bottomless pit and a great chain in his hand.

And he laid hold on the dragon, that old serpent, which is the Devil, and Satan, and bound him a thousand years.

And when the thousand years are expired, Satan shall be loosed out of his prison,

And shall go out to deceive the nations which are in the four quarters of the earth, Gog and Magog, to gather them together to battle: the number of whom is as the sand of the sea.

CHAPTER 20: 1-2, 7-8

T HE SPIRIT of the knight heard the painful cries of the unfortunate souls who, inside the hideous beast, were shouting their strident lamentations in such great numbers that no one could count them .... [Then the angel said] ... "But in the end, He will render to each what is due according to his deserts. For that reason, guard yourself carefully ... so that you will never again deserve these pains and torments."

THE VISIONS OF TONDAL

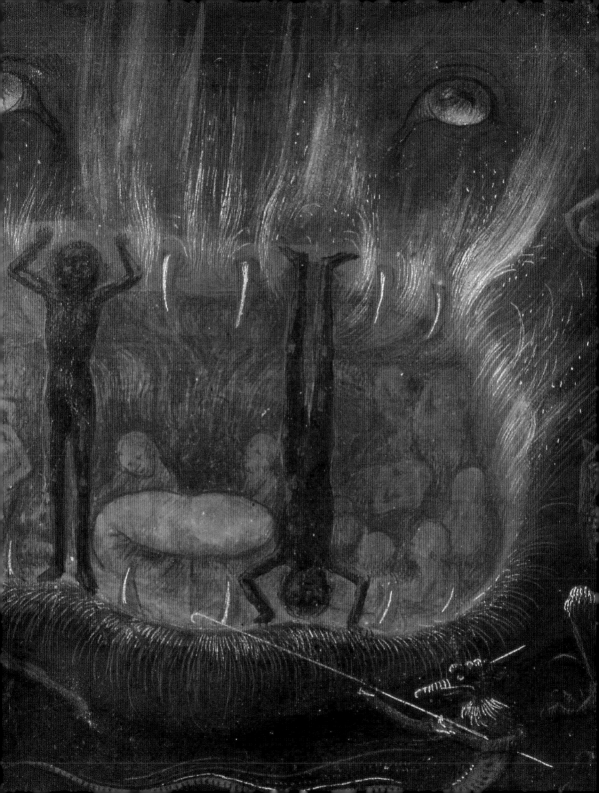

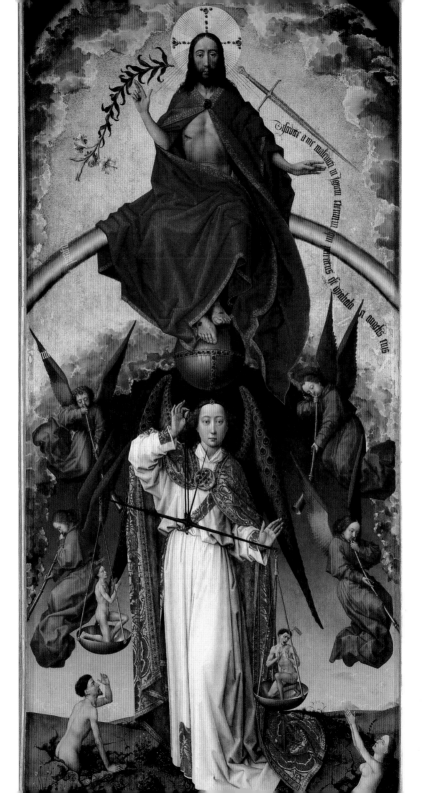

ND I SAW THE DEAD, small and great, stand before God; and the books were opened: and another book was opened, which is the book of life: and the dead were judged out of those things which were written in the books, according to their works.

CHAPTER 20: 12

A ND THE SEA gave up the dead which were in it; and death and hell delivered up the dead which were in them: and they were judged every man according to their works.

And death and hell were cast into the lake of fire. This is the second death.

And whosoever was not found written in the book of life was cast into the lake of fire.

CHAPTER 20: 13-15

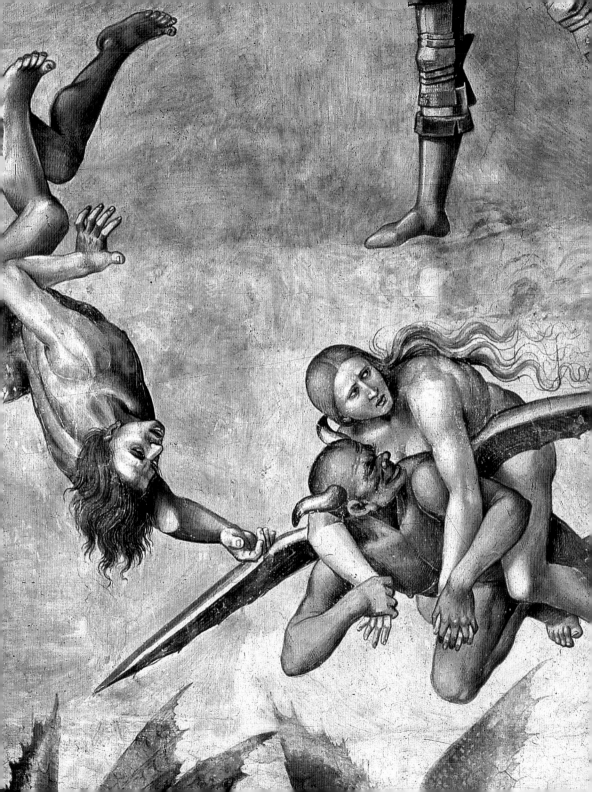

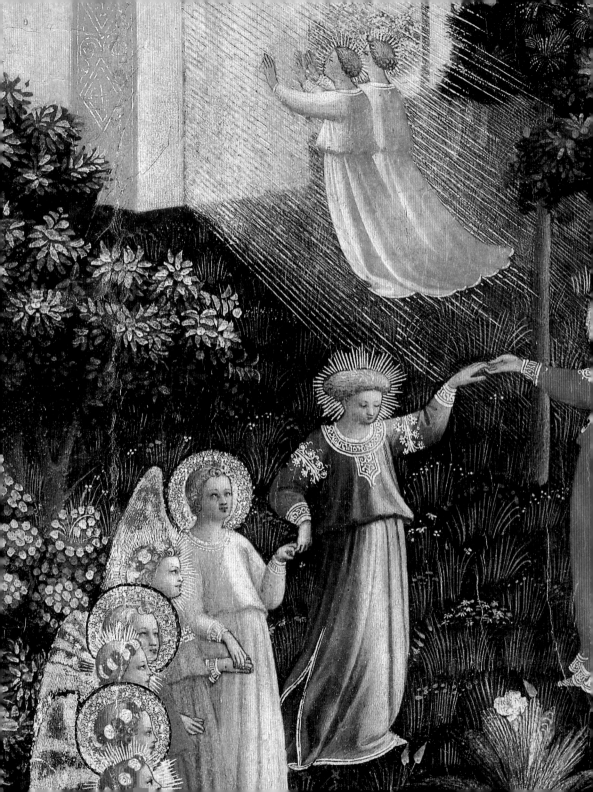

# A

ND I SAW a new heaven and a new earth: for the first heaven and the first earth were passed away; and there was no more sea.

CHAPTER 21: 1

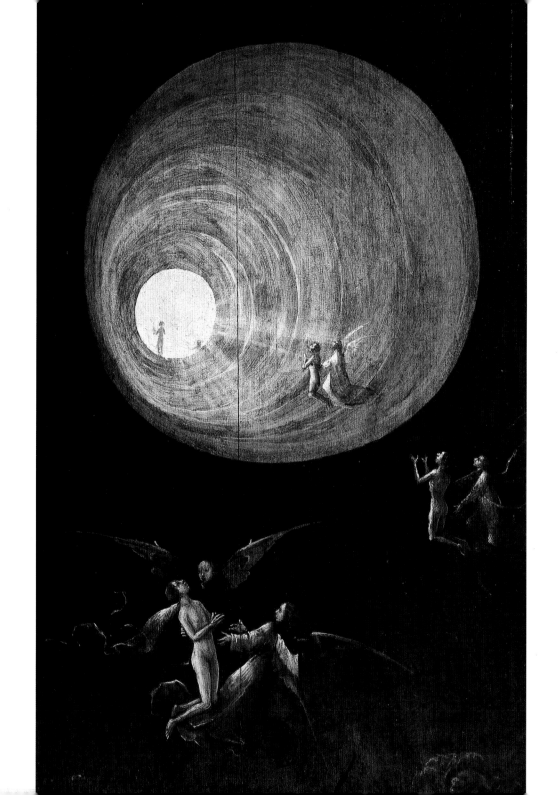

**A**ND I HEARD a great voice out of heaven saying, Behold, the tabernacle of God is with men, and he will dwell with them, and they shall be his people, and God himself shall be with them, and be their God.

CHAPTER 21: 3

AND GOD shall wipe away all tears from their eyes; and there shall be no more death, neither sorrow, nor crying, neither shall there be any more pain: for the former things are passed away.

And he that sat upon the throne said, Behold, I make all things new.

CHAPTER 21: 4-5

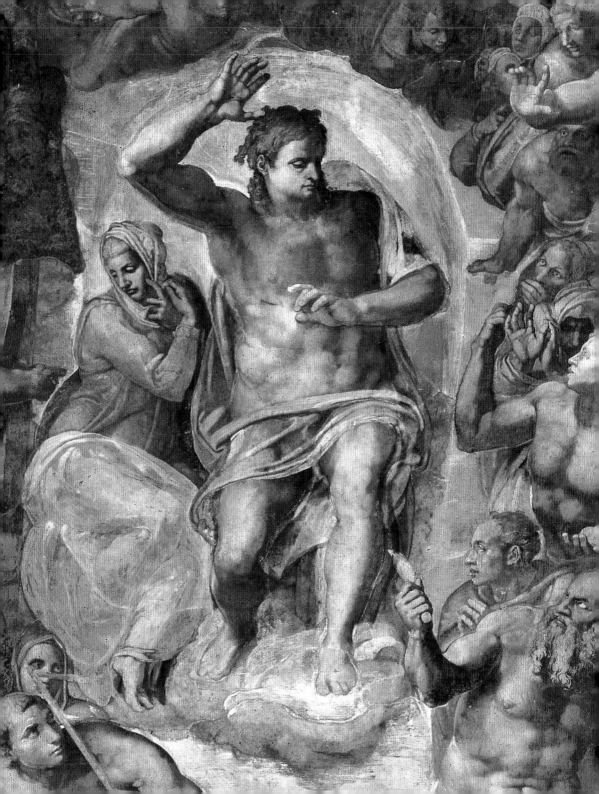

# AND HE CARRIED

me away in the spirit to a great and high mountain, and shewed me that great city, the holy Jerusalem, descending out of heaven from God.

And the nations of them which are saved shall walk in the light of it: and the kings of the earth do bring their glory and honour into it.

And the gates of it shall not be shut at all by day: for there shall be no night there.

CHAPTER 21: 10, 24-25

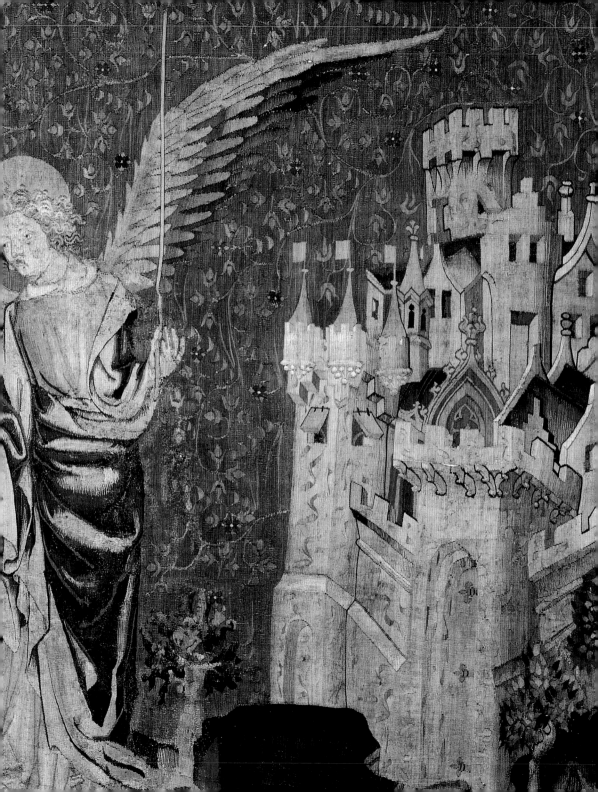

ND HE SHEWED ME a pure river of water of life, clear as crystal, proceeding out of the throne of God and of the Lamb.

CHAPTER 22: 1

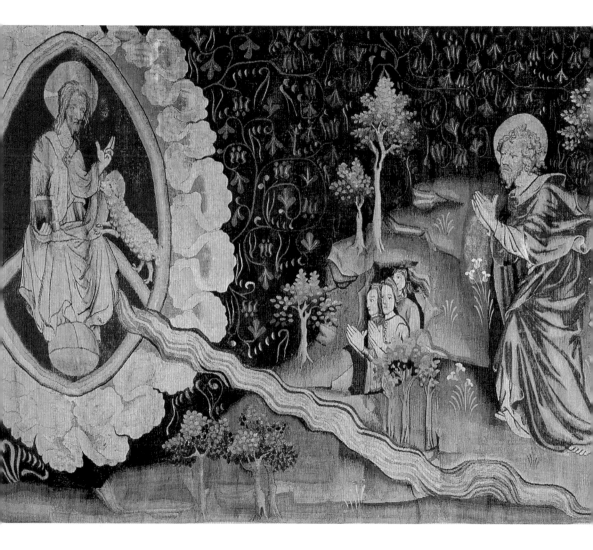

ON EITHER SIDE of the river was there the tree of life, which bare twelve manner of fruits, and yielded her fruit every month: and the leaves of the tree were for the healing of the nations.

CHAPTER 22: 2

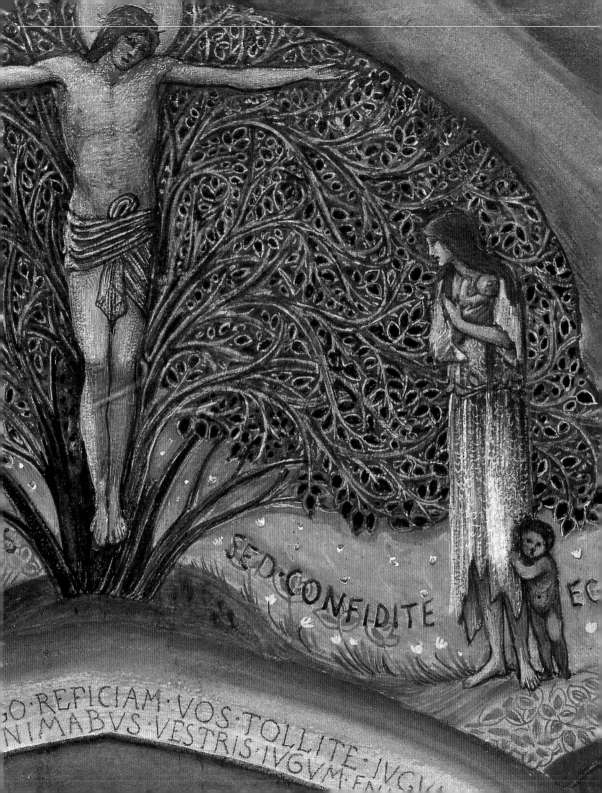

SED·CONFIDITE
EC

GO·REFICIAM·VOS·TOLLITE·IVGV
NIMABVS·VESTRIS·IVGVM·EN

ND HE SAITH unto me, Seal not the sayings of the prophecy of this book: for the time is at hand.

I am Alpha and Omega, the beginning and the end, the first and the last.

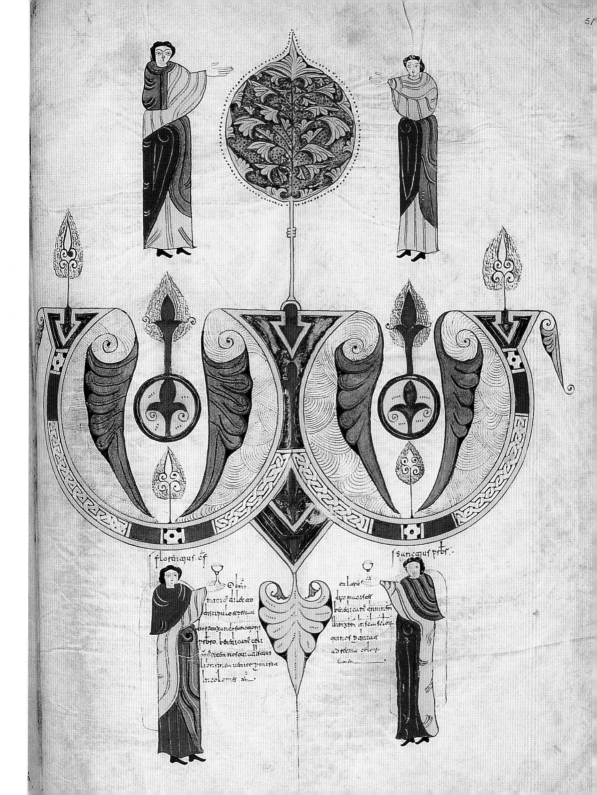

# INDEX OF ARTISTS AND PAINTINGS

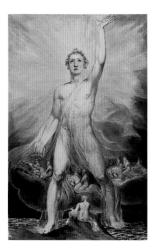

Pages 8-9
**St John the Divine on Patmos** *(detail)*
Predella panel from the Altarpiece of San Marco
SANDRO BOTTICELLI (c. 1445-1510)
*Galleria degli Uffizi, Florence*

Page 5 *(title page)*
**Angel of the Revelation**
WILLIAM BLAKE (1757-1827)
*The Metropolitan Museum of Art,
New York*

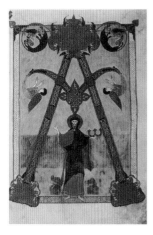

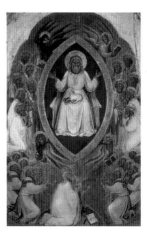

Page 11 *(left)*
**Initial 'Alpha'**
[Ms. 14-2, fol. 6r]
COMMENTARY ON THE
APOCALYPSE (1047)
BEATUS OF LIÉBANA
*Biblioteca Nacional, Madrid*

Page 12 *(left)*
**God the Father Enthroned**
Polyptych of the Apocalypse
JACOBELLO ALBEREGNO
(died 1397)
*Galleria dell'Accademia, Venice*

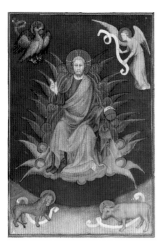

Page 15 *(left)*
**Psalms of Penitence: Christ in Majesty**
[Ms. 11060-11061]
LES TRÈS BELLES HEURES DU
DUC DE BERRY
(early 15th century)
JACQUEMART DE HESDIN
*(fl. 1384-1409)*
*Bibliothèque Royale de
Belgique, Brussels*

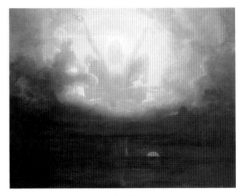

Page 17
**Apocalypse** *(detail)*
FRANCIS DANBY (1793-1861)
*Private Collection*

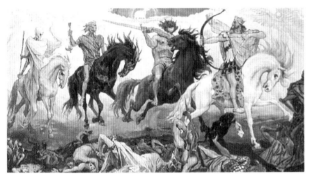

Pages 18-19
**The Four Horsemen of the Apocalypse** *(detail)*
VICTOR MIKHAILOVICH VASNETSOV (1848-1926)
*Museum of Religion, and Atheism, St Petersburg*

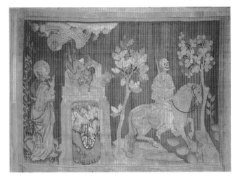

Pages 20-21
**The Opening of the Fourth Seal: Death on a Pale Horse** *(detail)*
No.12 in THE APOCALYPSE OF ANGERS series
NICOLAS BATAILLE *(fl. 1363-1400)*
*Musée des Tapisseries, Angers*

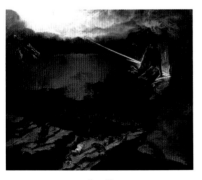

Page 23
**The Sixth Seal** *(detail)*
FRANCIS DANBY (1793-1861)
*Victoria Art Gallery, Bath*

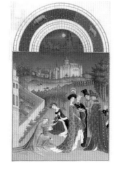

Pages 24-25
**February** *(detail)* [Ms. 65/1284, fol. 2v]
LES TRÈS RICHES HEURES DU DUC
DE BERRY (early 15th century)
*Musée Condé, Chantilly*

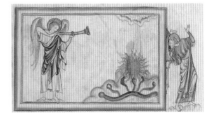

Page 27
**The Third Trumpet: The Burning Star Falls
into the River**
[Ms. Ludwig III 1, fol. 12]
DYSON PERRINS APOCALYPSE (c. 1255-1260)
*The J. Paul Getty Museum, Los Angeles*

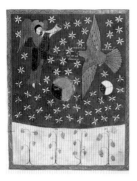

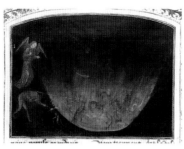

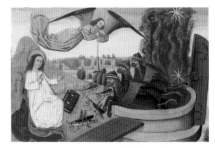

Pages 28-29
**The Fourth Angel of
the Apocalypse** *(detail)*
[Ms. Latin 8878, fol. 141]
THE ST SEVER APOCALYPSE
(mid-11th century)
*Bibliothèque Nationale, Paris*

Page 31
**The Valley of Fires, for Those Who Commit
Evil upon Evil** [Ms. 30]
LES VISIONS DU CHEVALIER TONDAL (1475)
*The J. Paul Getty Museum, Los Angeles*

Page 33
**The Fifth Angel Sounding the Trumpet**
[Ms. 68, fol. 184v]
COMMENTARY ON THE APOCALYPSE (15th century)
*The Pierpont Morgan Library, New York*

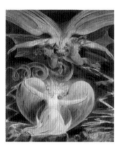

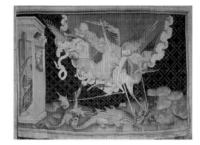

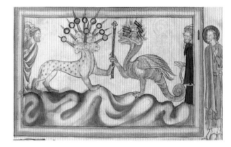

Pages 34-35
**The Great Red Dragon and the
Woman Clothed with the Sun**
*(detail)*
WILLIAM BLAKE (1757-1827)
*National Gallery of Art,
Washington (Rosenwald
Collection)*

Page 36
**St Michael and his Angels Fighting the Dragon**
*(detail)*
No. 36 in THE APOCALYPSE OF ANGERS series
NICOLAS BATAILLE *(fl.* 1363-1400)
*Musée des Tapisseries, Angers*

Page 39
**The Dragon Giving the Scepter of Power to the Beast
from the Sea**
[Ms. Ludwig III 1, fol. 23v]
DYSON PERRINS APOCALYPSE (c. 1255-1260)
*The J. Paul Getty Museum, Los Angeles*

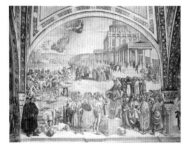

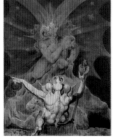

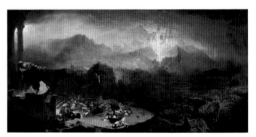

Page 41
**The Preaching of the Antichrist** *(detail)*
LUCA SIGNORELLI (c. 1440/50-1523)
*Orvieto Cathedral*

Page 43
**The Number of the Beast
is 666**
WILLIAM BLAKE (1757-1827)
*Rosenbach Museum & Library,
Philadelphia*

Pages 44-45
**Armageddon** *(detail)*
JOSEPH PAUL PETTIT (1812-1882)
*York City Art Gallery*

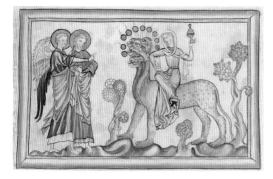

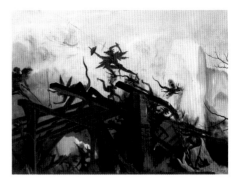

Pages 46-47
**The Great Harlot on the Scarlet-Colored Beast** *(detail)*
[Ms. Ludwig III 1, fol. 36]
DYSON PERRINS APOCALYPSE (c. 1255-1260)
*The J. Paul Getty Museum, Los Angeles*

Pages 48-49
**Angel Attacking the Devils** *(detail)*
The Isenheim Altarpiece
MATTHIAS GRÜNEWALD (c. 1480-1528)
*Musée d'Unterlinden, Colmar*

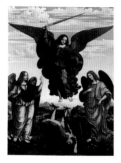

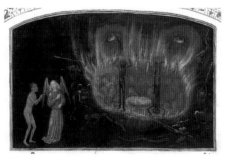

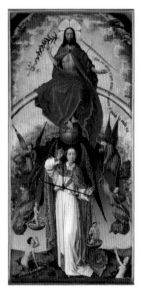

Page 50
**The Archangels Triumphing
over Lucifer** *(detail)*
MARCO D'OGGIONO (c. 1475-1530)
*Pinacoteca di Brera, Milan*

Pages 52-53
**The Beast Acheron, Devourer of the Avaricious**
[Ms. 30]
LES VISIONS DU CHEVALIER TONDAL (1475)
*The J. Paul Getty Museum, Los Angeles*

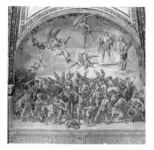

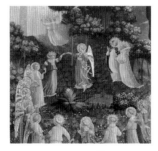

Page 54
**Christ as Judge of the World: Archangel Michael
Weighing Souls**
Centre panel of Altarpiece
ROGIER VAN DER WEYDEN (c. 1399-1464)
*Hotel-Dieu, Beaune*

Pages 56-57
**Devils** from **The Damned** *(detail)*
LUCA SIGNORELLI (c. 1440/50-1523)
*Orvieto Cathedral*

Pages 58-59
**Paradise** from **The Last Judgement**
*(detail)*
FRA ANGELICO (c. 1395-1455)
*Museo di San Marco, Florence*

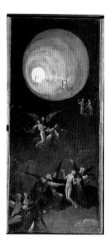

Page 60 *(left)*
**The Ascent into Heavenly
Paradise** *(detail)*
HIERONYMUS BOSCH
(c. 1450-1516)
*The Doge's Palace, Venice*

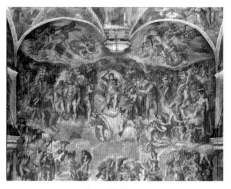

Pages 62-63
*The Last Judgement (detail)*
MICHELANGELO (1475-1564)
*Sistine Chapel, Vatican, Rome*

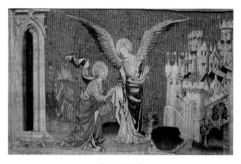

Pages 64-65
**Measuring the New Jerusalem**
THE APOCALYPSE OF ANGERS series
NICOLAS BATAILLE (fl. 1363-1400)
*Musée des Tapisseries, Angers*

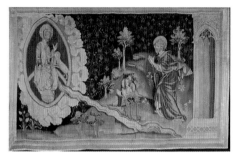

Page 67
**The River of Paradise**
No. 82 in THE APOCALYPSE OF ANGERS series
NICOLAS BATAILLE (fl. 1363-1400)
*Musée des Tapisseries, Angers*

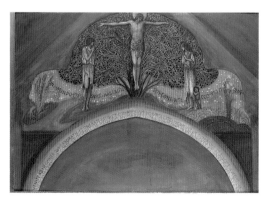

Pages 68-69
**The Tree of Life** *(detail)*
SIR EDWARD BURNE-JONES (1833-1898)
*Private Collection*

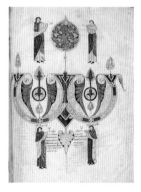

Page 71
**Omega** *(fol. 514)*
LEÓN BIBLE OF 960
*Real Colegiata de San Isidoro, León*

# PHOTOGRAPHIC ACKNOWLEDGMENTS

For permission to reproduce the paintings on the preceding pages and for supplying photographs, the Publishers would like to thank:

AKG London: 11, 28-29, 54 (photo Erich Lessing), 56-57, 60
Bonhams, London/Bridgeman Art Library, London/New York: 68-69
Bridgeman Art Library, London/New York: 8-9, 12, 15, 17, 44-45
The J. Paul Getty Museum: 27, 31, 39, 46-47, 52-53
Giraudon/Art Resource, New York: 20-21
Giraudon/Bridgeman Art Library, London/New York: 24-25, 36, 48-49, 67
The Metropolitan Museum of Art, Rogers Fund, 1914 (14.81.1): 5
(Photograph © 1980 The Metropolitan Museum of Art)
National Gallery of Art, Washington © 1999 Board of Trustees: 34-35
Novosti/Bridgeman Art Library, London/New York: 18-19
The Pierpont Morgan Library/Art Resource, New York: 33
Real Colegiata de San Isidoro, León: 71
Rosenbach Museum and Library: 43
Scala, Florence: 41, 50, 58-59, 62-63, 64-65
Victoria Art Gallery, Bath and North East Somerset Council/Bridgeman Art
Library, London/New York: 23